BASICS

MODELBUILDING

\ \ ALEXANDER SCHILLING

BASICS

MODELBUILDING

BIRKHÄUSER – PUBLISHERS FOR ARCHITECTURE
BASEL·BOSTON·BERLIN

CONTENTS

FOREWORD

Models are a way of representing planned structures. Since they help create a spatial impression of what will become the constructed environment, they are an important means of presentation both while studying architecture and in professional practice. Although three-dimensional sketches can convey a spatial impression, models allow viewers to choose their own perspective and experience space in an individual way.

But models are also an important tool for designers – one that helps them to arrive at the right proportions and form, as well as to review sketched ideas in three dimensions and to develop their ideas in the first place. In this very concrete way, models provide support for the design and decision-making process.

This "Basics" book series aims to provide instructive and practical explanations for students who are approaching a subject or discipline for the very first time. It presents content with easily comprehensible introductions and examples. The most important principles are systematically elaborated and treated in depth in each volume. Instead of compiling an extensive compendium of specialist knowledge, the series aims to provide an initial introduction to a subject and give readers the necessary expertise for skilled implementation.

This volume examines scaled-down representations of buildings in the form of models. Modelmaking has become an independent art form with its own tools, techniques and materials. Since students are often forced to learn the techniques and general rules of model building on their own, this book will present background knowledge and practical tips.

In addition to introducing different types of models, common tools and machines, we will systematically discuss suitable materials and explain them with an eye toward their effects as compositions. The description of the typical model-building process includes tips and pointers that will enable students to benefit from the diverse opportunities of modelling and to transform their designs into aesthetic and representational models.

Bert Bielefeld
Herausgeber

THE ARCHITECTURAL MODEL AS A MEANS
OF REPRESENTATION

What is
modelmaking?
In the early Renaissance in Italy, modelmaking evolved into the most important means of architectural representation. It not only supplemented architectural drawings, but was often the primary method used to convey ideas and depict spaces. Ever since then, architects, engineers and clients have used models to represent designed buildings.

Plans (design sketches such as technical plans) and architectural models are both means of depicting buildings and spaces, yet plans convey only two dimensions. Once the design and the project have been thought out and sketches and details drawn, it is time to tackle the object in space. While it is true that only the finished building can communicate a complete understanding of three-dimensional effects, models anticipate the subsequent construction process. Seen this way, models represent architecture on a smaller scale. Work on models is of great importance, particularly in architectural studies, since students do not usually have the opportunity to build their own designs.

Motivation: why
build models?
A model is not absolutely necessary to complete a design or architectural assignment successfully, yet it can be a useful tool in many ways: the model's scaled-down size makes it possible to examine the quality of the design and allows designers to develop a feel for space, aesthetics and materials. The additional advantages of a model include its communicative and persuasive potential: a model helps designers to demonstrate to themselves and others the quality of their ideas or projects. In addition, the model can serve as a control mechanism for assessing the building before it is built.

Working models
– three-
dimensional
sketches
Architectural students are often confronted with the challenges of modelmaking in their first year at college. They quickly see that the models they built as children – trains, planes and ships – have nothing to do with the demands made on them in their studies. The green lawn from their train set is of no interest to professors or lecturers. The toys of childhood are now professional reality.

So how should students proceed? Let us assume they have been given a design assignment and require a model, on a pre-defined scale, that will play an important role in the way their proposed solution is evaluated. Whether they use a model in their design work will largely depend on both how they design and how the design evolves. If the spatial structure is

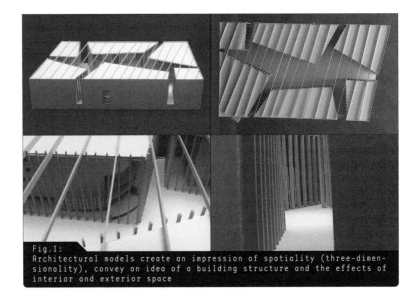

Fig.1:
Architectural models create an impression of spatiality (three-dimensionality), convey an idea of a building structure and the effects of interior and exterior space

of greater complexity than a two-dimensional drawing can represent, a model may be the only way to depict it. Simple models, so-called <u>working models</u>, enable designers to find solutions and test ideas. The ideas that do not work on the model can be rejected.

The working model accompanies the entire design process. Once this process is complete, the goal is then to illustrate the ideas and concepts that are essential for the design. The viewer must be convinced of the feasibility of both the concept and the proposed solution.

\\Hint:
Working models have earned their name because designers can "work" with them. They can, and should, be modified even if that harms their quality. It is therefore best to build a model that is easy to take apart and reassemble. Students can join parts with pins or easily removable rubber cement. Once two parts are glued together, they are committed to a particular form, which is not the purpose of a working model.

\\Tip:
Working models, which support the design process experimentally, can also be used effectively for presentational purposes if they are sufficiently refined. Elements such as building sections and topographic layers should be assembled temporarily both to ensure that the model can be modified and to avoid unnecessary stains and damage during work. Painting at a later stage in the process is an excellent way of enhancing a working model.

The presentation model, built with a great deal of effort to be almost perfect, marks the completion of the design process. At universities, this type of model is used to present a design idea – the concept. In architectural competitions, it depicts the proposed solution and competes with the designs of other participants. In both cases, the model supplements the architectural plans submitted. New media are often used to present drawings: three-dimensional computer-generated images provide a very realistic rendering of how the future structure will look. Photo-realistic representations are another modern way of simulating a spatial experience. A model cannot perform all these functions. It always remains an abstraction of the reality it portrays. Its only true function is to translate the sketched idea into three-dimensional form.

\\Tip:
It is always difficult to build a presentation
model when under pressure to submit a design.
It is often more efficient to make parts of
the model in advance or use a site model
as both working and presentation model. A
presentation model does not need to be perfect
or to be made of the very best materials. All
that is needed is a very convincing model.

TYPES OF MODELS

Abstraction
– the trick of
miniaturization

A model is a more or less abstract, miniaturized representation of reality. But what does abstraction mean in modelmaking?

The opposite of abstract is concrete. In painting, "concrete" refers to an object that is portrayed as accurately as possible. In contrast, abstraction as applied to architectural models shifts the focus onto the subject matter, the informational value of the object portrayed and the spatial framework. What is at stake is not an accurate portrayal of reality but a process of simplification, which guides the eye to the model's essential features. It is crucial to find a suitable form of abstraction, one that reflects the selected scale. This point can be illustrated using the example of windows: on a scale of 1:200, a window is usually portrayed as a precisely cut-out aperture in the surface of the chosen material. On a scale of 1:50, a window is much easier to see. Glass is reproduced using a transparent material, and the window frame is built of small bars. Another example is façade cladding: on a very small scale, it cannot be depicted at all, but in larger models this element has greater relevance and is included in the design. The façade can be simulated very realistically using the right material.

Relationship
between
scale and
representation

At the very start of a project, modellers must select the scale of their models. The dimensions in which an architectural object can be represented illustrate the role that scale plays. Depending on the scale and level of abstraction, there exist a number of model types, which will be explained below.

CONCEPTUAL MODELS (WITHOUT A CONCRETE SCALE)

A spatial pictogram can generally be described as a conceptual model. Here, the underlying idea of a design or a creative concept is depicted in an

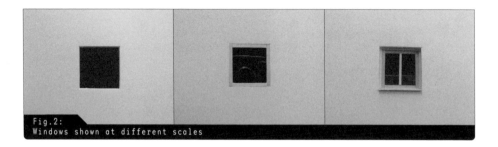

Fig.2:
Windows shown at different scales

entirely abstract manner as a three-dimensional object (e.g. using a meta-
phor as a basis). Material, form and colour highlight structures and create
compositions. The model can, for instance, be used to visualize the results
of urban space analyses at the start of the design process. By exploring a
theme or place on a spatial yet abstract level, architects can alter or im-
prove the view of that place. A model can support this approach.

URBAN DESIGN AND LANDSCAPE MODELS, SITE AND TOPOGRAPHY (SCALE 1:1000, 1:500)

This type of model represents urban or natural environments. It is
the first step in the representation process, since it shows the relationship

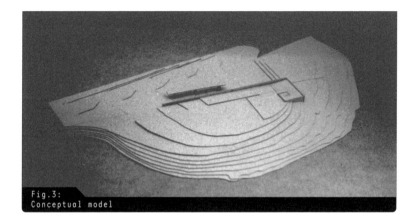

Fig.3:
Conceptual model

with the existing environment. In urban space, it is important to show how the context changes with the addition of a new structure.

This type of model is characterized by the highest level of abstraction. Buildings are reduced to "building blocks" – to abstract structures that reproduce building form and three-dimensionality in a highly simplified manner. Even so, the model includes the characteristic features of buildings such as recessions, projections, bay windows and roof designs. In its abstract form, the site – the scaled-down landscape – is simplified and depicted, in the chosen material, as a level plain. If the landscape slopes, it can be broken down into horizontal layers that are stacked on top of each other in the model.

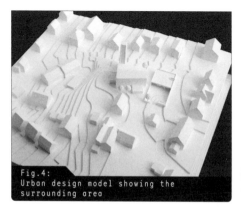

Fig.4:
Urban design model showing the surrounding area

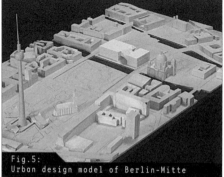

Fig.5:
Urban design model of Berlin-Mitte

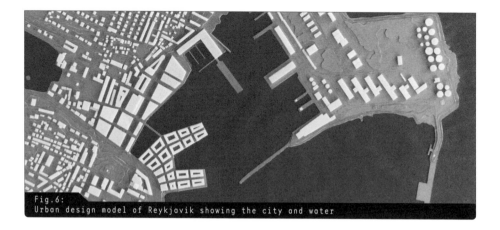

Fig.6:
Urban design model of Reykjavik showing the city and water

If the model is meant to reproduce uneven landscapes, the first step in building it is to conceive of the irregular natural terrain as a stack of horizontal layers. The more finely layered the material, the more precise and homogeneous the resulting model will be (width of the elevation layers: 1.0 mm or 2.0 mm). The work is based on a plan that shows contour lines or, at least, provides information on elevation. Once the real topographic situation is known, contour lines (curved, straight or polygonal) are drawn. Depending on the material, the modeller can cut out each layer with a utility knife or saw before arranging the layers on top of each other.

A single assignment might include several designs, and urban design models are often constructed as "inserts" or group models to reduce the amount of work required to present them. Only one model of the surrounding area is made, and each participant is given a mounting board for the section on which he or she is working. This particular section is omitted from the urban design model so that the inserts can be interchanged.

ARCHITECTURAL/BUILDING MODELS
(SCALE 1:200, 1:100, 1:50)

The building model is a common illustrative tool for simulating an architectural design. While larger objects such as museums, schools and

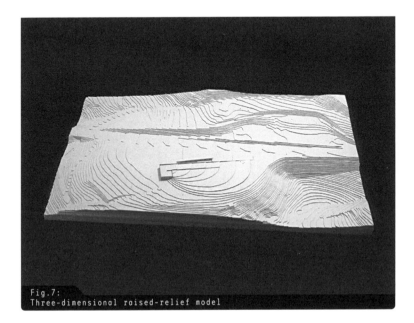

Fig.7:
Three-dimensional raised-relief model

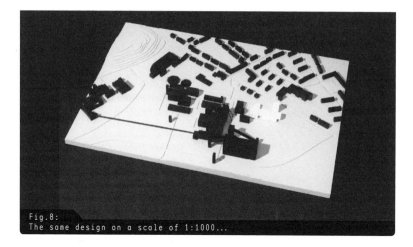

Fig.8:
The same design on a scale of 1:1000...

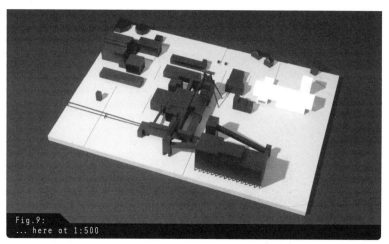

Fig.9:
... here at 1:500

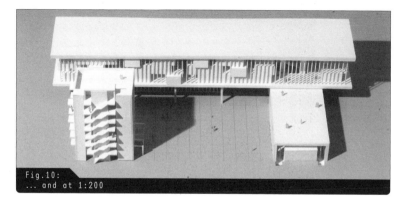

Fig.10:
... and at 1:200

churches are usually represented on a scale of 1:200, 1:500 is common in competitions. In addition to three-dimensional forms and volumes, the design's many and diverse features play a more significant role here than in urban design models.

From drawing to model

Façade design is extremely important. On a reduced scale, the elements that are visible on the building exterior catch the eye, including:

_ The façade – surface, structure, features, material qualities
_ Apertures and what fills them (windows) – embrasure, wall widths
_ Roof type and design – specific details such as roof overhangs or parapets

The building model can also convey information on the interior space and building structure. For example, a sectional model (divided into two parts built on separate mounting boards) can provide views of important interior rooms. In combination with removable floors and other interior components, a modeller may alternatively use a removable roof element that affords a glimpse into the model from above.

Depending on the purpose of the design, the model can also be reduced to its structural or conceptual components for greater illustrative effect.

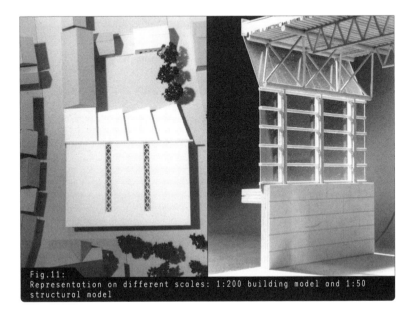

Fig.11:
Representation on different scales: 1:200 building model and 1:50 structural model

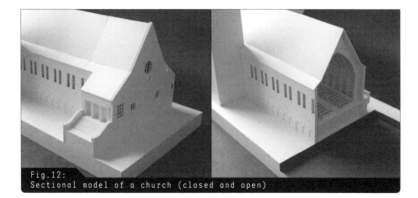

Fig.12:
Sectional model of a church (closed and open)

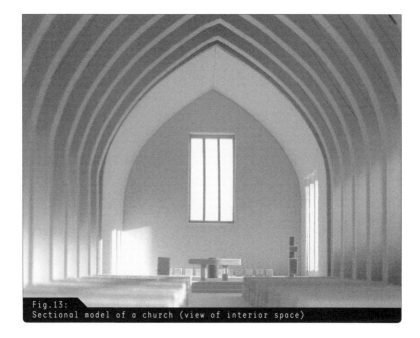

Fig.13:
Sectional model of a church (view of interior space)

INTERIOR MODELS (SCALE 1:20, 1:10, 1:5, 1:1)

When spaces such as bars, chapels or living areas are depicted, it is often advantageous to use a model to provide an accurate and detailed simulation of a real situation. Abstraction plays only a subordinate role in these models. The overriding goal is to portray real objects and materials on a small scale.

17

How can surfaces, elements and objects be reproduced on a small scale while maintaining the effect they have on the structure as a whole? Let us use the model of a chapel interior to explain the process. The design uses just a few materials for the finished building. Combined in a simple way, they possess the specific properties that are crucial for the spatial atmosphere and the overall concept. The linoleum floor of the real building is reproduced with linoleum in the model. Wood composite board is painted white to represent the real white plaster surfaces. Glass is used for glass. The resulting construction is both a three-dimensional model and a collage of materials.

The best way to simulate a real material is to use it in the model. For instance, model builders can reproduce fair-faced concrete in a large-scale model using concrete. They need only to build miniature formwork, fill it with a fine mixture of cement and sand, pack it down and let it dry. The results are impressive! In this case, modelmaking scales down the entire construction process, simulating not only the finished object, but the process itself.

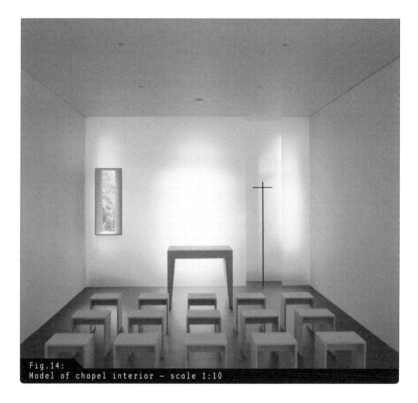

Fig.14:
Model of chapel interior — scale 1:10

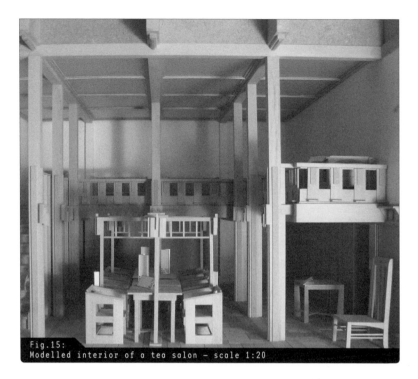

Fig.15:
Modelled interior of a tea salon – scale 1:20

The general rule is: the factors that have the greatest influence on the effect of the real building must be successfully reproduced in the model. This will make the model an effective representation of designed space. Modellers often achieve a stunning effect with their interior models, making it impossible for viewers to distinguish between a photograph of the modelled space and the real spatial situation.

DETAILED MODELS (SCALE 1:20, 1:10, 1:5, 1:1)

Detailed models are not only used in the field of interior design but also as structural or technical models (details). In principle, these models can be made on a scale of up to a 1:1, although in this case it would probably be more accurate to call them "prototypes". Model builders must first decide whether they wish to include furniture, lamps and similar details, and how they can do so most effectively. Creativity knows no bounds when it comes to putting old objects to new uses. Such objects can provide a basis for 1:10 scale models of tables and chairs or serve as simple building blocks or abstract volumes.

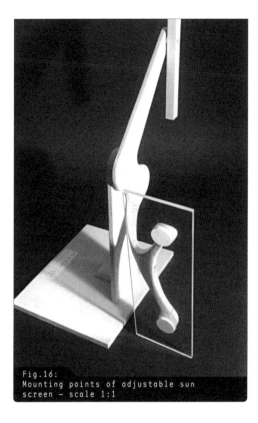

Fig.16:
Mounting points of adjustable sun
screen — scale 1:1

Fig.17:
Multiplex plywood cabinet handle —
scale 1:1

DESIGN AND CONCEPT DEVELOPMENT

Even a model
needs a concept

Modelmaking is a creative process that requires a design concept in addition to the right tools and materials. › see chapter Equipment, tools and techniques The finished architectural model must be an aesthetic object that impresses people with its content and design. The following explanations are offered to help students develop designs:

_ Colour – monochrome or polychrome models
_ Material contrasts – differing material properties
_ Composition
_ Proportions
_ Level of detail ("abstraction")

COLOUR AND MATERIALS

Monochrome
models

After deciding whether a model should be built of wood, cardboard, metal or plastic, modellers must determine how many different materials they need in total. Generally speaking, one material will suffice if it can be modified in different ways. The advantage of surfaces with a uniform texture and colour is that the represented space will remain the focus and not compete with the material or the model itself for attention. Building monochrome models is a common approach. Most models in architectural competitions are executed as "white models" of plaster and polystyrene plastic: the goal is to direct the viewer's eye exclusively to the architectural or urban design project. Wooden models usually require only one type of wood. It goes without saying that the aesthetics of the selected material will be shown to best effect if other components do not detract from them. If it is nevertheless important to differentiate between components or elements, modellers can use paints, clear varnishes etc. › see chapter Materials

Differentiating elements and surfaces is part of the design concept. Accurately simulating the combination of elements in the model is thus a time-tested method of modelmaking.

A few architectural examples:

_ Smooth plaster surfaces can be combined with a roughly textured brick wall.
_ Solid concrete and stone elements can be used to contrast light, delicate structures of wood and steel.
_ Transparent or translucent elements (glass building envelope) can be combined with opaque sections.

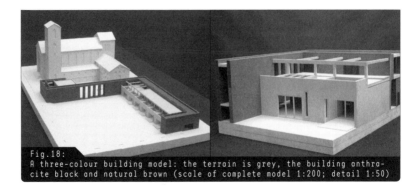

Fig.18:
A three-colour building model: the terrain is grey, the building anthracite black and natural brown (scale of complete model 1:200; detail 1:50)

If contrast is part of the architectural idea, it should generally be featured in the model. In such cases, representing materials in a simplified way to create a more abstract impression does not give the necessary clarity and precision. However, if different materials are combined, modellers should stick to what is absolutely essential to avoid a hodgepodge of materials.

COMPOSITION AND PROPORTION

Modelmaking replicates a process that has already taken place during the design work. The most important question is how materials can be combined to exploit their contrasts, whether hard or soft, dark or light, heavy or light, rough or fine. A great deal of experimentation may be necessary to make the final selection and to ensure that the composition of materials captures what the modeller wishes to convey. It is only after these issues have been resolved that the actual modelmaking should begin.

Interplay of elements

How do we "compose" a model? The goal is to enhance the design concept using the methods of modelmaking.

Modellers should first consider the following questions:

_ How can the detail be selected so that the building model is in proportion to the dimensions of the overall representation?
_ Will the project be positioned at the centre of the representation, or are there reasons to abandon this principle?
_ What are the relationships between the individual elements within the model (colour, material qualities, proportions)?

ABSTRACTION AND LEVEL OF DETAIL

Along with the right materials, the mode of representation plays a key role in determining the final result. It is essential that all parts of the model have the same degree of abstraction. For example, there is no sense in accurately reproducing the site and the surrounding buildings if the model of the new building remains abstract.

Establishing the scale of the model will determine the level of abstraction. In modelmaking, abstraction means stripping things down to their essentials. Non-essential items can be ignored or left out. But what exactly are the essentials?

Abstraction = interpretative freedom

In this context, it is important to consider the effects of the selected level of abstraction: a precise, detailed model lays claim to portraying a sound, thought-out design. If the model is meant to provide a great deal of information, viewers will be given relatively little freedom in imagining it. A detailed, miniature version of the real structure will convey a very concrete idea of the intention of the design and keep viewers from imagining their own details. As a rule of thumb, a high level of detail is an advantage when dealing with clients and laypeople. The more realistic the model, the clearer the impression people will have of the building and the architecture.

What degrees of detail are possible in modelmaking? In principle, the only limits are what is technically possible, or what is possible within the given deadline. If a window is too small to be cut out with a utility knife at the selected scale, it should be left out.

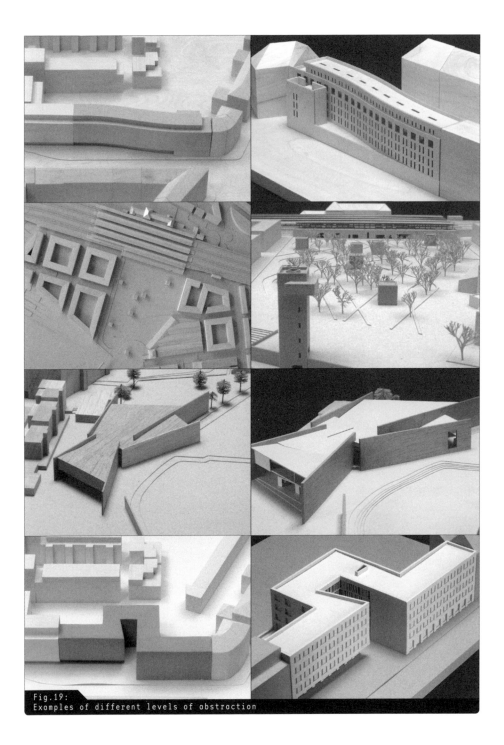

Fig.19:
Examples of different levels of abstraction

A more abstract model tends to convey principles and ideas, with details fleshed out at a later stage. The model remains conceptual. Architects often prefer this type of minimalist representation to grant free rein to the imagination and to enable various interpretations of the subsequent building. They are not forced to commit themselves.

Accessories The use of trees, figures, cars and other accessories in modelmaking must also be considered in conjunction with the level of abstraction. It is often easier to convey a concrete idea of a design to a lay audience if the model depicts not only the architecture and the site but also elements that are familiar to them from daily life, such as cars, trees, plants and people. "Human scale" is the most important yardstick in real life, but it is not always apparent in a model. › see chapters Materials, Accessories: trees, figures and cars

Precision Modelmaking is often associated with terms like perfectionism, exact workmanship and precise execution. These standards are generally justified when presentation models are made, but precision on its own does guarantee a good model. It is not even the prerequisite for one. An idea can be portrayed clearly without a lot of work. More important than perfection is the modeller's "signature" style, which we have mentioned above, and which gives the model the required expressive power. As a creative approach, a broad stroke can be as effective as the detailed representation of the large object on a miniature scale.

EQUIPMENT, TOOLS AND TECHNIQUES

When building small spatial objects, many students will feel the same passion that drew them to architecture as a profession in the first place. Others will prefer pencils and drawings to the tools of the modellers' trade. Whatever their preference, all architectural students will be confronted with the demands of modelmaking in their very first semester. What is the simplest way to build a model?

CUTTING

The simplest method is to work with a utility knife and a piece of paperboard or cardboard. The utility knife is an essential modelmaking tool since it can be used to cut a variety of materials in their original form. It is simple and inexpensive, and many different versions are available for different cutting tasks. We recommend purchasing a high-quality knife instead of the simple carpet knives found in many home improvement stores. The blade must be firmly attached and must not move during cutting. Ideally, the knife will fit comfortably in the hand so that it can be held and guided effectively. The selection of a knife is just as important as the choice of a good pencil.

> 🔪

In addition to the universally deployable utility knife, a variety of other cutting tools are available at speciality shops. The scalpel, the well-known surgical instrument, can be used to make fine cuts in materials or cut out very small windows from cardboard.

> ✎

🔪

\\ Hint:
Many modellers have had painful experiences with the utility knife, especially when working under time pressure. To minimize the risk of injury, you should always handle tools with the utmost care and only use them for the work for which they are intended. For instance, you should not to try to cut a hard piece of wood with a utility knife due to the danger of slipping.

✎

\\ Tip:
When using a utility knife to cut cardboard, you should hold the knife as close to the surface as possible in order to make precise, clean cuts. If this is not done correctly, the material may tear and increase the risk of injury since the sharp blade is more likely to slip.

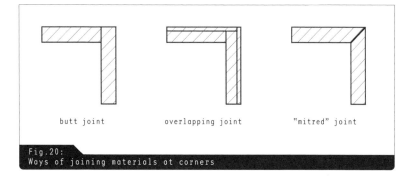

butt joint overlapping joint "mitred" joint

Fig.20:
Ways of joining materials at corners

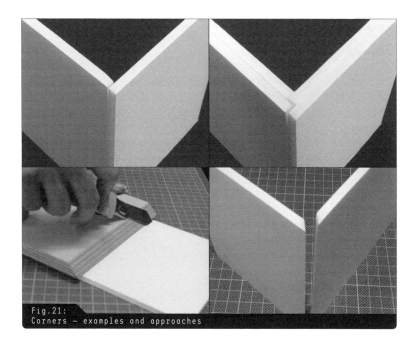

Fig.21:
Corners – examples and approaches

How should cuts be made? First, the required edge should be marked with a thin pencil; after cutting, this thin mark will no longer be visible. The edge should then be cut at a 90° angle to the surface so that the individual parts can be butt-jointed or glued together.

At corners the edges of the material can also be cut at a 45° angle to form mitred joints. Special utility knives with slanted blades are available to make such cuts. Another method is to make a wooden board with a 45°

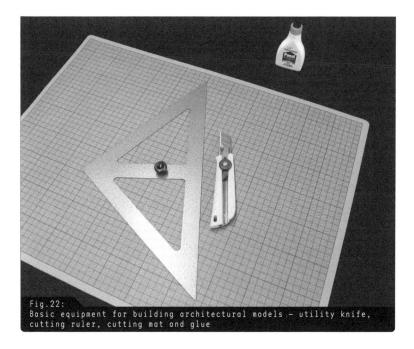

Fig.22:
Basic equipment for building architectural models – utility knife,
cutting ruler, cutting mat and glue

edge and use it as a kind of a template for guiding the blade of a standard
utility knife.

In other cases, a metal-edged ruler can be used to guide the knife and
ensure a straight cut. Another important tool is a hard cutting mat, which
not only protects the tabletop but also makes for a better quality cut than
a soft base. We recommend plastic cutting mats.

These are the only tools a modellers needs to build simple, practi-
cal working models out of cardboard and pasteboard. But other tools are
necessary to intensively work the material, including:

_ Sandpaper: required to smooth surfaces, finish cut edges and re-
move sharp pieces from cut-out holes. If sandpaper is wrapped
around a firm, stable base such as a sanding block, it is easier to
move back and forth over the part that needs sanding.
_ File: excellently suited for finishing the corners and edges of a va-
riety of materials. Files are available for both wood and metal. It is

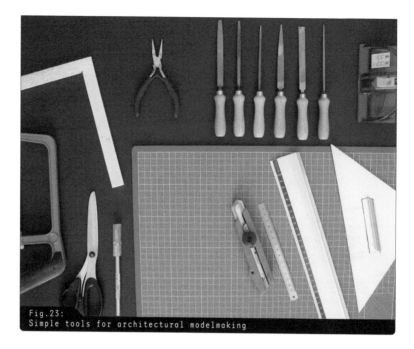

Fig.23:
Simple tools for architectural modelmaking

generally possible to use the same tools when working on plastics or metals – for instance, a fine iron saw lends itself well to cutting plastic.
_ Tweezers: increase the precision of the human hand and allow modellers to work on even the smallest parts. Small-scale models may contain parts that are only a few millimetres in size and nearly impossible to grasp with the fingers.
_ Measuring instruments ("sliding calipers"): are used to measure diameters and cross sections accurately. Since the trained eye can detect even the tiniest size differences on a small-scale model, precise measurements are an important aspect of modelmaking. Precision extends to one tenth of one millimetre, a unit that cannot be measured with normal rulers.
_ Measuring tools (ruler and measuring stick): for the precise measurement of lengths and dimensions.

GLUING

Depending on the materials to be glued, modellers have a wide range of products at their disposal. Whereas all-purpose glues can be used universally for many different materials, white glue is the perfect choice for all types of wood, wood-based materials and cardboard.

Table 1:
Overview of glues

Glue	Properties	Application
All-purpose glue	Generally a solvent-based artificial resin adhesive that is transparent, viscous and may become stringy when applied. Reacts with some plastics (e.g. Styrofoam), melting their surfaces. Usually dries in just a few minutes. A light irritant; non-aging	Can be used for various materials (e.g. cardboard, wood, plastics, metals, glass, fabric etc.). Parts can be glued to the same or different materials. The glue does not cause cardboard to buckle and is often all that is needed in modelmaking thanks to its great diversity.

White glue (wood glue)	Has a white, viscous consistency and dries by absorbing the moisture in the bonded material. Transparent and slow drying, meaning the glued surfaces can be moved for a while after application. Fast-drying "express glue" dries in 3–5 minutes.	Ideal for woods, wood-based materials, cardboard and paperboard. The parts must be pressed together for an effective bond. The glue's high moisture content may change the shape of the material and cause cardboard to buckle. Not suitable for plastics, metals or materials that cannot absorb moisture.
Contact glue	Used to bond large surfaces. The glue is applied to both parts and bonds with itself. After application, the parts must dry for a few minutes before they are bonded together, and it is important to apply firm pressure. Contact glue should only be used in well-ventilated rooms.	Ideal for gluing large surfaces (e.g. cardboard) in raised-relief models. Since the glue is applied to both parts and the room must be ventilated, this is a time-consuming method, but it has the advantage of not buckling the materials. Can be used for wood, cardboard, a large number of plastics, metals and ceramics.
Plastic-bonding adhesives	A fluid, usually clear glue containing solvent. Specially designed for plastics and the single-sided application of glue. The parts must be joined quickly while the glue is still wet, and the surfaces must be free of dust and grease.	Can be used for many thermoplastics, including polystyrene, PVC and perspex, but not suitable for polyethylene or poly-propylene. Can also be used to bond wood or cardboard (see all-purpose glue), and are more effective than all-purpose glue for plastics.
Super glue	Transparent, very fast-drying glue; viscous and non-dripping.	Ideal for connections that cannot be held together and that require an instant bond.

Spray glue	Colourless, UV-resistant, CFC-free glue that comes in a spray bottle and does not change colour when applied. Due to its low moisture content, it does not permeate the material. Spray glue should only be used out of doors or in well-ventilated rooms.	Ideal for application to large surfaces, such as in cardboard raised-relief models. The materials may buckle or warp slightly, but do not usually wrinkle. Can also be used to glue paper or cardboard to different backgrounds, especially when large surfaces must be glued.
Solvent	Used to bond plastics. The solvent melts the surface of the material, and pressure is applied to "weld" the two parts together. Example: dichloromethane (methylene dichloride), which like all organic solvents is extremely harmful to human health.	For gluing polystyrene, perspex or polycarbonates; bonds both parts without residue by dissolving the thermoplastic resin. Use only in very well-ventilated rooms.
Rubber cement	An elastic adhesive that is easy to remove, normally without any residue. If applied to both parts, it creates a permanent bond.	Can be used for various materials including paper, cardboard and plastics. Ideal for use in working models or montages
Double-sided tape	A basic alternative to fluid bonding agents, useful because of its instant bond. The properties of the bonded materials are not adversely affected by moisture.	Can be used for bonding large surfaces, and ideal for all types of materials, including PE and PP, which cannot be joined with other adhesives. The materials do not buckle, warp or wrinkle. Not suitable for joining small points.

MODELLING, SHAPING AND CASTING

An alternative method for building working models is to use plasticine or another modelling clay.

Plasticine is usually sold as a greyish-green modelling material whose plasticity varies with temperature. It is hard to knead plasticine at room temperature, but it becomes softer and easier to work once it is slightly warmed up (e.g. on a warm radiator). Plasticine can also be heated in a pot, and in fluid form, it can be applied to a surface with a putty knife or brush.

Modelling clay lends itself well to experimental work with a model. It is excellently suited to studies of urban space and enables modellers quickly to build many different versions of the same object. Small structures can be quickly and easily cut off with a knife.

By working the clay with their hands or tools, modellers can gain a feel for the manual work and its results. The finished object may not be a very precise model, but the modelled form can be a very expressive way of representing space.

Plaster (gypsum) is an inexpensive material that is very easy to work with. Even so, making a plaster model is a time-consuming process because it requires two steps:

_ First, an exact negative mould is made of the subsequent three-dimensional object and liquid gypsum is poured into it. The precision of the mould determines the quality of the final result.
_ After the plaster dries, the cast object is removed from the mould.

Plaster models are often used in architectural competitions, particularly for urban design models, since here the same site model must be

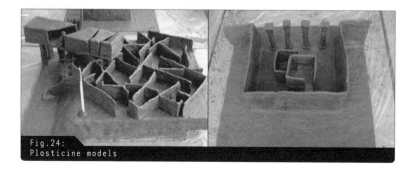

Fig.24:
Plasticine models

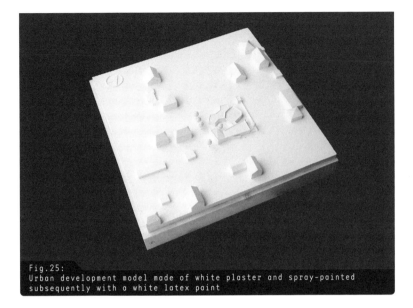

Fig.25:
Urban development model made of white plaster and spray-painted subsequently with a white latex paint

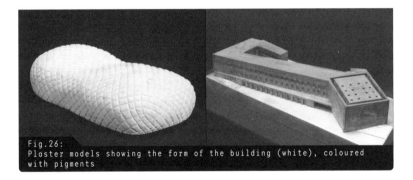

Fig.26:
Plaster models showing the form of the building (white), coloured with pigments

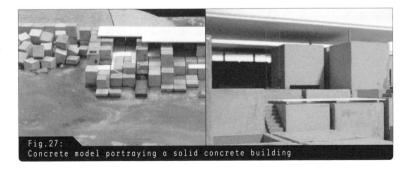

Fig.27:
Concrete model portraying a solid concrete building

made several times and using a single mould is convenient. Colours can be portrayed by adding pigments or liquid paint to the plaster or by smoothing and painting the surface after it dries. These models not only create a solid, heavy impression, but are solid and heavy themselves.

It goes without saying that other pouring compounds can be used besides plaster. If fair-faced concrete needs to be represented, modellers can use concrete in the model.

MACHINES IN THE MODELLING WORKSHOP

Working with
machines

The simple tools and methods described here are sufficient for working with easily processed materials. However, many materials require the use of machines and professional tools in order to achieve the desired result.

Tools in the
carpenter's
workshop

Many professional architectural modellers use the same tools that can be found in most carpenters' workshops:

_ Handsaws
_ Files, rasps and sanding blocks
_ Planes
_ Chisels and mallets
_ Set squares

Sawing

A power saw is commonly used when a utility knife is no longer sufficient. Although a knife can be used to work on veneer, wood is a material that usually requires the use of a saw.

In addition to the usual commercial <u>table saws</u> – saws with round blades and benches – table saws of a smaller size, called micro table saws,

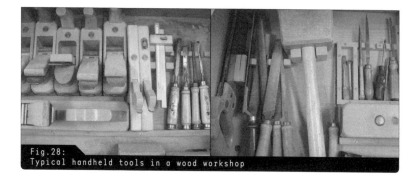

Fig. 28:
Typical handheld tools in a wood workshop

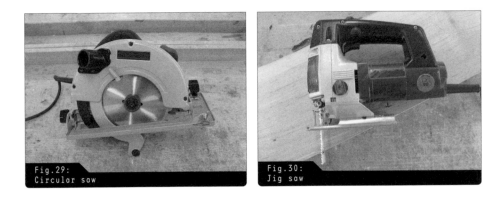

Fig.29:
Circular saw

Fig.30:
Jig saw

are also available for (professional) modellers. If the correct blade is used, these fine power tools can be used for cross cutting and profiling wood, as well as for cutting plastic. It is very helpful to have precisely these kinds of tools at hand when building wooden models. With the use of the fence, it is possible to cut materials both across and with the grain. It should be noted, however, that students will require a certain amount of training and time to become familiar with such saws and the specific features of materials to be worked.

In addition to the table saw, which is useful for straight cuts, the band saw is an important tool for curved and free-form cuts. This machine is useful for sawing solid wood cross sections. Jig saws are also useful for cutting free-form and curved lines.

Planing

A plane is used to reduce the thickness of wood or to modify the surface of cross sections. By planing the surface of terrain models, the modeller can make differences in elevation more apparent.

\\ Tip:
Using wood for architectural modelling is extremely attractive, as the result lives from the aesthetic of this material. Even so, use of the required machines like the table saw or grinding machines should be supervised by professional joiners or modellers, particularly at the beginning.

\\ Tip:
In addition to tools available in hardware stores and DIY centres, creative modellers can often make their own tools using very simple materials. A good example is a miniature file consisting of a thin piece of square iron pipe and fine sandpaper. It is also possible to use everyday items. For instance, a clothespeg works well as a clamp when gluing.

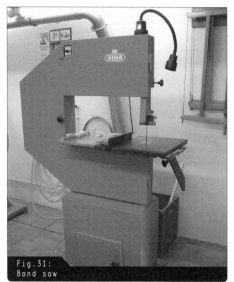

Fig.31:
Band saw

Fig.32:
Table saw

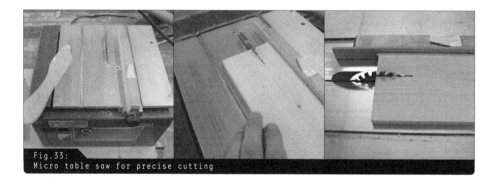

Fig.33:
Micro table saw for precise cutting

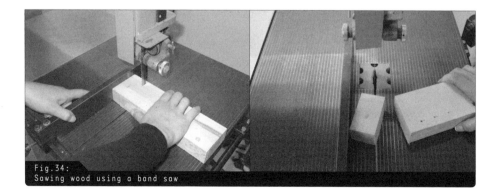

Fig.34:
Sawing wood using a band saw

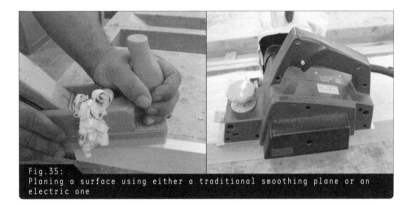

Fig.35:
Planing a surface using either a traditional smoothing plane or an electric one

Fig.36:
A handheld power drill with no type of guidance system

Drilling

A <u>drill</u> is useful for making connections, for example when dowels are used on the base of a model to represent columns or trees. Holes bored in the base material are perfect connections for these elements and increase stability as well.

Of utmost importance when using a drill is the correct guidance of the tool. In workshops, drills are usually clamped into a drill stand so that the angle at which the drill enters the material can be set precisely and locked in place. The micro drills available for modelling have very small chucks and can be used with drills with a diameter of less than one millimetre.

Milling

A <u>milling machine</u> enables a modeller to cut into the surface of wood.

The different types of milling bits › see Fig. 37 that can be attached to the machine allow modellers to cut roads, rivers, depressions and other features into the surface of a raised-relief model. This machine offers new

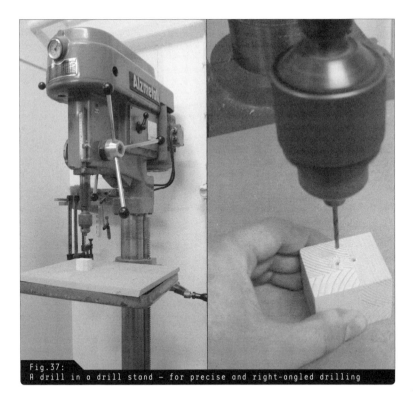

Fig.37:
A drill in a drill stand — for precise and right-angled drilling

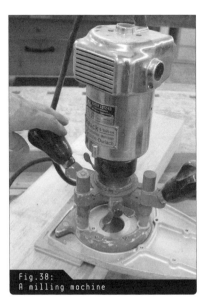

Fig.38:
A milling machine

woodworking options in addition to those possible with the saws outlined above.

Sanding

There are various ways to sand an object in order to produce the final shapes and surfaces. Power tools make the work much easier than manual sanding with sandpaper. It is of fundamental importance when sanding that the proper type of sandpaper – e.g. for metal or wood – be used for each material. Coarse sanding can be done using coarsely grained sandpaper, and a finely grained paper should be used afterwards. A power <u>disc sander</u> is a very helpful tool. A rotating sanding disc is combined with a flat work surface so that large surface areas can be finely sanded. Just as with table saws, micro sanders are also available to carry out the fine and precise operations necessary for precise modelmaking.

In addition to flat disc sanders there are also tools with rounded sanding surfaces, which are useful for the smoothing off round shapes. They include <u>belt sanders</u> and <u>oscillating sanders</u>, which are guided by hand across the surface in question.

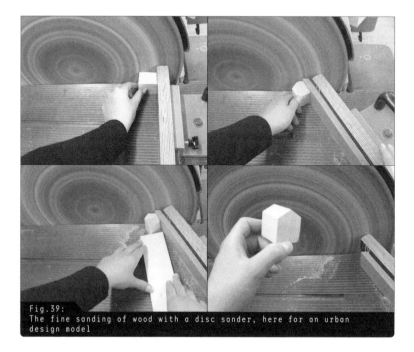

Fig.39:
The fine sanding of wood with a disc sander, here for an urban design model

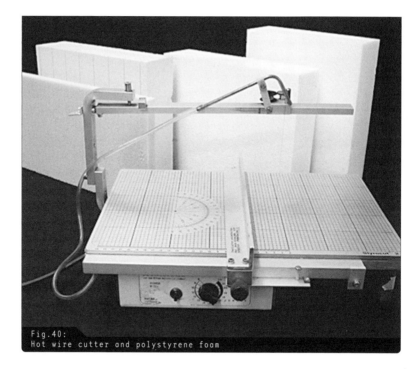

Fig.40:
Hot wire cutter and polystyrene foam

HOT WIRE CUTTERS

A hot wire cutter (Styrocut) is a common tool among architecture students. It allows for the simple, fast and precise cutting of thick polystyrene foam and can be used to make individual pieces for an urban design model or mass models during the planning process. The hot wire cutter consists of a cutting table and a fine wire, which is heated up by a low voltage energy supply and slices through the foam material.

COMPUTER MILLING

The use of computers has transformed the field of architecture, particularly in representing complex organic forms and structures. CAD software and CNC (computerized numerical control) milling machines – a modern digital tool for architectural modelling – have played the biggest role in this change. Strictly speaking, the use of CNC milling for three-dimensional representation involves nothing more than the use of CAD software for two-dimensional drafting. Just as the draughtsperson's methods have been digitalized, so has architectural modelling by the CNC milling machine.

Technically, CNC milling machines, which are usually controlled along three spatial axes (x, y and z) by the computer, are able to produce models with an extremely high degree of precision and perfection. The cutting and engraving bit cuts out geometrically and spatially complex shapes from a variety of suitable materials, just as a digital plotter can produce finer and more accurate line drawings than can be made using manual methods. In addition, models can be produced as often as desired, and

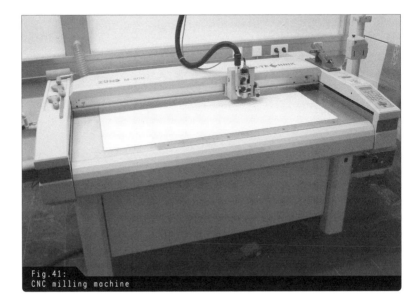

Fig.41:
CNC milling machine

the individual parts are always identical. This machine therefore opens a broad field of possibilities for graphic representation that were not available before. Some passionate modellers nevertheless feel that items produced using CNC milling machines have no character of their own.

Many universities now offer these new digital methods in addition to traditional modelling workshops as part of architectural studies. Depending on the type of machine, all necessary modelling data (base topography or information about a building, including the structure of the façade in vectorized form) must be available before any milling can take place. These data enable the machine to cut the correct shapes out of the material. Problems occur if the milling machine's software cannot adequately translate the CAD file (due to older file standards, for example). This means that everything has to be drawn once again.

To achieve optimum results with CNC milling machines, modellers must allow sufficient time for test runs with this modern technology. It is important to note whether the cutting head moves to the left or right of a pre-defined line, or directly on the line itself.

Not all materials are suited for use with a CNC machine. Aluminium, brass, steel and stainless steel can be used in sheet form (a thickness of 3 mm to 5 mm is common). Perspex of superior (moulded) quality can be used in thicknesses of up to 10 cm, as is the case for plastics such as polystyrene. Wood products such as plywood (e.g. birch and multiplex plywood, and MDF) can also be used.

MATERIALS

Which material
for which model? Strictly speaking, a model is nothing more than a scaled-down version of an existing situation or a future building. In the practice of modelling this means that actual surfaces are transformed into a model through a process of abstraction. An attempt is nevertheless made to retain the specific qualities of materials and the effect they might have, because in the end a building's appearance comes primarily from the sum of the materials from which it is made. Materials are matte or shiny, rough or smooth, heavy and solid or light and filigree. This raises the question of which materials the model should incorporate in order to simulate reality best. In this regard modelling is the same as real construction. A wide variety of materials are available. Some have been used in architectural modelling for a long time and are considered "classic" materials; others are new; and others still were originally intended for different purposes. Specific characteristics are necessary to create particular effects. Glass can be simulated using transparent materials, water by reflective materials, and walls can be reproduced using layered materials made of small modules with a regularly or irregularly structured surface.

Below, materials are described together with their uses and methods of preparation. Materials can be categorized on the basis of their specific sources:

_ Paper, paperboard and cardboard
_ Wood and wood-based products
_ Metals
_ Plastics

Other important materials are:

_ Paints and varnishes
_ Plaster and clay

🔖
\\ Hint:
Most projects can be easily built using these
materials. In addition their ease of use, they
have the advantage of being inexpensive and
readily available in many places.

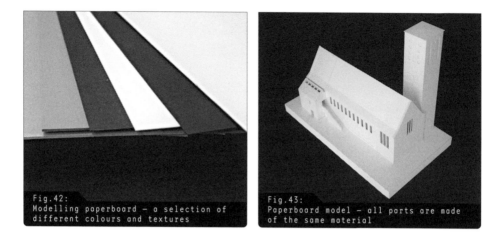

_ Plasticine and modelling clay
_ Prefabricated parts for modelling such as figures, vehicles and
other accessories

PAPER, PAPERBOARD AND CARDBOARD

A wide variety of these materials exist on the market, and there is no
limit to the creativity with which they can be used in architectural model-
ling. Many products, including grey paperboard, were actually developed
for the packaging industry but are nonetheless very popular among mod-
ellers.

Table 2 (page 47) gives an overview of the most common types of pa-
perboard. Paper, including coloured paper or tracing paper, is also a useful
material for modelling. Cardboard, sold under names such as Mill blank,
coloured board, glossy board or Chromalux board, can also be used, as can
paper and cardboard with structured surface textures.

Photo cardboard

Photo cardboard, like thinner coloured paper, is particularly well
suited for representing different coloured surfaces. It is available from
many manufacturers in a wide variety of colours, and is a stable material
for the work due to its thickness.

Glossy
cardboard

Glossy cardboard's name leaves little doubt as to the material's spe-
cial feature. Because of its glossy exterior this cardboard is always suit-
able for representing reflecting or mirrored surfaces. Its many different
colours are also an advantage in addition to its shine.

45

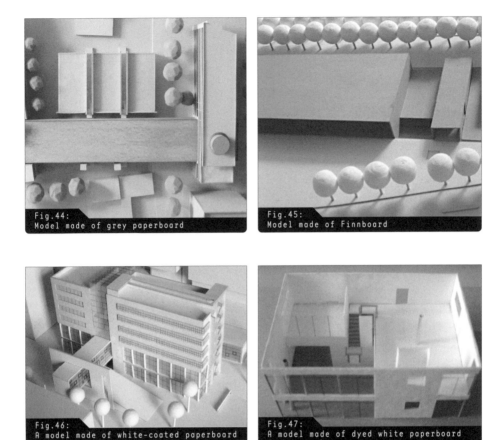

Fig.44:
Model made of grey paperboard

Fig.45:
Model made of Finnboard

Fig.46:
A model made of white-coated paperboard

Fig.47:
A model made of dyed white paperboard
(Chromalux)

Corrugated
cardboard/
wellboard

Materials that are inexpensive or available for free are always very practical for building working models. Corrugated cardboard is primarily produced and used for packaging and can be "recycled" and used for modelling. The advantages that the material brings to packaging also apply to modelling:

_ It is easy to cut using a utility knife
_ Thicknesses of up to 6 mm make it easy to work with
_ The structure of this material (corrugated cardboard core, covered on both sides with smooth cardboard) means that it keeps its shape and remains stiff despite its light weight
_ It is also suitable for use with raised-relief models

Table 2:
Paperboard — uses and characteristics

Material	Properties	Use	Processing
Finnish wood pulp board (also known as Finnboard)	Made of wood fibres; beige, woody colour; darkens when exposed to sunlight (yellowing); smooth and rough textures; available in thick-nesses approx. 1.0–4.0 mm	General use for topographic layers and buildings, interior models with simulated daylight (due to its light surface)	Easy to cut; easy to stick together using white or all-purpose glue; surfaces can be varnished or painted to prevent yellowing or aging
Grey paperboard	100% recycled; warm grey tone; smooth and rough textures; available in approx. 0.5–4.0 mm thick-nesses according to manufacturer	General use for topographic layers and buildings	Easy to cut; easy to stick together using white or all-purpose glue; surfaces can be varnished or painted
Serigraphy board	Wood fibreboard with bonded texture; available in approx. 1.0–3.0 mm thickness	Ideal for spatial models (scale 1:50); simulation of light due to white surface colour	Easy to cut; easy to stick together using white or all-purpose glue; surfaces can be painted with acrylic paints or printed with silk-screen dyes

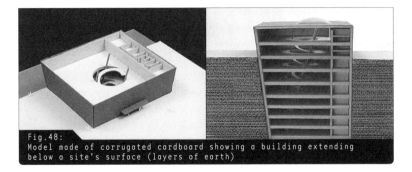

Fig.48:
Model made of corrugated cardboard showing a building extending
below a site's surface (layers of earth)

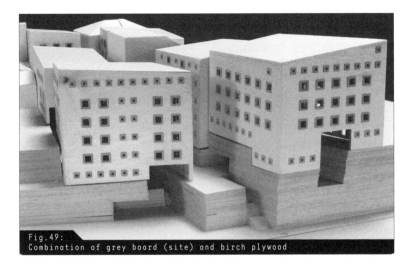

Fig.49:
Combination of grey board (site) and birch plywood

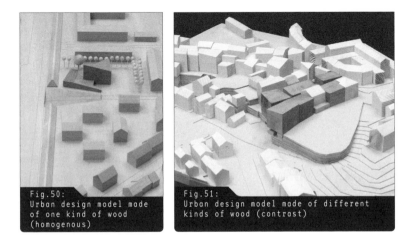

Fig.50:
Urban design model made
of one kind of wood
(homogenous)

Fig.51:
Urban design model made of different
kinds of wood (contrast)

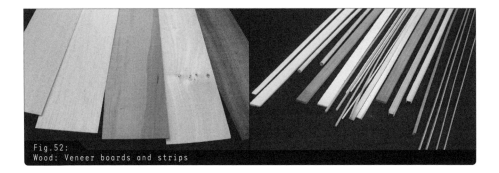

Fig.52:
Wood: Veneer boards and strips

WOOD AND WOOD-BASED MATERIALS

Wood has been used longer than any other "construction material" for building architectural models. Even Michelangelo used the wood of a linden tree to make a model of Saint Peter's dome. Wood is much more work-intensive than paperboard; the results, however, are much more impressive. Wood is used above all for presentation models. As a natural raw material, wood has its own aesthetic, which is expressed independently of an architecture model's shape, design and finish. Nuances in colour and the structure of the grain give wood the appearance of a "living" component of a model.

There are two basic categories: naturally grown and dried wood, and industrially processed wood-based products. Both are used in modelling.

\\ Tip:
A wide variety of good-quality wood is available at timber yards as well as in small carpentry workshops and wood-processing firms. An overview of the various types of wood from all over the world is nearly impossible, but professionals are usually happy to advise architects and students about the correct choice of wood for modelling. It may also be possible to observe carpenters and cabinetmakers as they work, and learn about how they deal with wood.

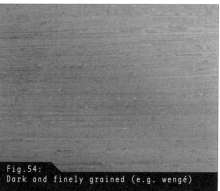

Fig.53:
Rich in contrast, with an even grain (e.g. elm)

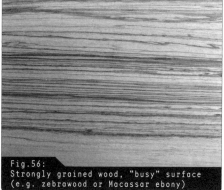

Fig.54:
Dark and finely grained (e.g. wengé)

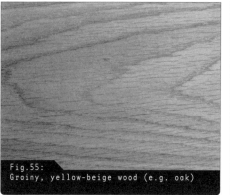

Fig.55:
Grainy, yellow-beige wood (e.g. oak)

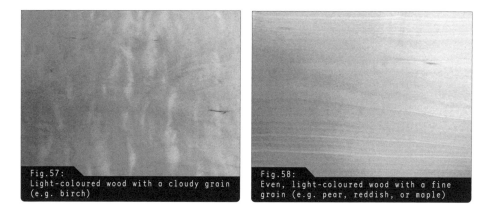

Fig.56:
Strongly grained wood, "busy" surface (e.g. zebrawood or Macassar ebony)

Fig.57:
Light-coloured wood with a cloudy grain (e.g. birch)

Fig.58:
Even, light-coloured wood with a fine grain (e.g. pear, reddish, or maple)

Tree species	Properties	Use	Processing
Abachi	Soft, light hardwood, low strength, light coloured, straw-yellow, slightly structured surface	Used for making decks in model ships. Veneer strips are used to represent wood surfaces (grooved, structured)	Veneer strips can be easily cut with a utility knife (along the grain). They bond excellently with white glue, or with an extensively applied spray adhesive
Balsa	The lightest of all commercial timbers. Shines slightly, has a whitish surface and a soft, velvety, homogenous structure	Especially suitable for making model aircraft. Veneer strips are used to represent wood; wood profiles to represent buildings	Simple to cut with utility knife or saw. The wood can break easily along the grain; very easy to bond with white glue
Beech	Strong hardwood, fine, uniform grain structure, light brownish-red colour	Suitable for all kinds of models: wooden blocks for representing urban developments; veneers for surfaces and model buildings	With standard wood-processing tools. Can be sawn and sanded. Very easy to bond with white glue.
Linden (lime)	Short-fibred, soft hardwood, plain surface, yellowish, light colour	One of the woods most commonly used in model construction. It is suitable for most purposes	Depending on dimensions, linden is very easy to process with a utility knife and saw
Mahogany	Very hard tropical wood, slightly shiny surface, dark, reddish-brown colour	Used to contrast with all light-coloured woods and modelling materials	Owing to its hardness it can only be processed with a saw and sanding tools

Maple	Soft hardwood, yellowish natural white colour; fine, differentiated grain pattern	Can be used for all types of models, wooden blocks in urban planning models and veneers for surfaces and models of buildings	With standard wood-processing tools, sawing and sanding. Very easy to bond with white glue
Pear	Evenly structured hardwood, light reddish-brown with a fine surface	Suitable for all sorts of models: wooden blocks for representing urban development schemes, veneers for surfaces and model buildings	With standard wood-processing tools, sawing and sanding. Very easy to bond with white glue
Pine	Long-fibred softwood with a typical, striking surface structure, yellowish colour	Its dimensional stability makes it very suitable for wood profiles in frame structures and construction models	Depending on dimensions pine is very easy to cut with both a utility knife and a saw
Walnut	Depending on origins: fine or coarse grain, deep dark brown colour	Used to contrast with all light-coloured woods and modelling materials. Very fine appearance	With standard wood-processing tools, sawing and sanding, very easy to bond with white glue

Wood and tree species

When a modelmaker is working with natural wood, he or she must use a kind that is also suitable for small-scale models. Coarse-grained wood species with distinct markings, such as Macassar ebony and zebrawood, are unsuitable. › see Fig. 56 The surface should look smooth and plain. The woods given in Table 3 are highly recommended.

Wood-based materials

Wood-based materials, which are usually supplied as panels, are made from the waste wood generated by the timber-processing industry. In the building industry, they are used for finishing furniture and interiors as well as for making architectural models. The boards are also used for making bases, such as the loadbearing substrates of models, and for large-scale models of interiors.

Wood-based material	Properties	Use	Processing
Chipboard	Reasonably priced wood panel, manufactured from wood shavings and glue, rough surface, material thicknesses: 6.0–22.0 mm	For making mounting boards, for depicting rough and structured surfaces with surface treatment	Processed like wood (sawing and sanding), very easy to bond with white glue. Can warp if exposed to excessive moisture
MDF	Hard, high-density wood fibreboard with homogenous, smooth board structure, high dimensional stability, flat surface, "natural brown" colour or stained in many different colours, including black	For mounting boards, raised-relief models and complete, large-scale (1:50) building models	Processed like wood, very easy to bond, the surface is treated by painting or staining
Plywood (birch, beech, poplar)	Glued-laminated wood panels made of several layers of one of these species, visible grain, same colour as that of the wood used	For raised-relief models and model buildings. Used as an alternative to models made of wood only, as plywood with small cross sections is also stable	Easy to process with utility knife or saw and, in some cases, with a milling machine (birch). Very easy to bond with white glue
Coreboard	Plywood made of glued wood; visible grain, same colour as that of the wood used	Suitable for mounting boards and bases	Processed like wood. Owing to its composition (glued rods) it can generally bear loads in one direction only

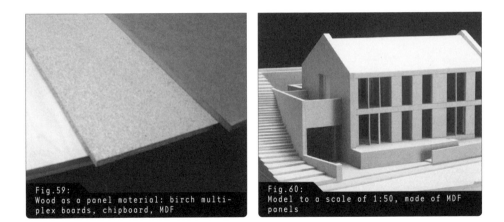

Fig.59:
Wood as a panel material: birch multi-
plex boards, chipboard, MDF

Fig.60:
Model to a scale of 1:50, made of MDF
panels

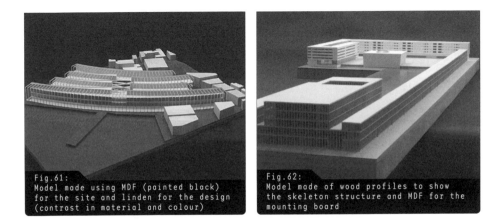

Fig.61:
Model made using MDF (painted black)
for the site and linden for the design
(contrast in material and colour)

Fig.62:
Model made of wood profiles to show
the skeleton structure and MDF for the
mounting board

METALS

Special care must be taken when representing metals, since their specific properties cannot be faithfully simulated with other materials. If a material is intended to convey the aesthetic idea behind the concept, it will also affect the impression created by the model too. Filigree steel columns and tension ties are ideal for representing thin metal profiles in situations in which the specific properties of other materials would cause these to fail.

Metal sheeting and profiles are used in architectural models. Smooth sheets, in thicknesses of approx. 0.2–4 mm can be used. There are also

Metal	Properties	Use	Processing
Aluminium	Silvery white, air- and water-resistant owing to thick, opaque, oxide layer that forms on the service, non-magnetic	Aluminium sheets and profiles can be used to represent metal building elements, e.g. corrugated sheet for the roof	Cannot be soldered. Bonded with glues (all-purpose glues), easy to polish, malleable
Brass	Alloy of copper and zinc. Red to light red, depending on the proportion of copper used. A golden colour can be produced by using a higher proportion of zinc	Brass sheets can be used to simulate shining gold surfaces; profiles can be used for loadbearing models (girders and columns)	Can be soldered. Bonds well. Depending on strength of material, it can be processed with metal tools. Polishes well
Copper	The only red metal, oxidizes in contact with the air, turning first red and then green	Copper sheeting and profiles should be used to represent copper in the model	Can be soldered; glues well. Depending on strength of material, it can be processed with metal tools. Polishes well
Iron and steel	Dark silvery colour, corrodes in contact with moisture and oxygen, resulting in formation of reddish-brown rust; magnetic	Steel sheets can be used to simulate metal surfaces, profiles can be used for load-bearing models (girders and columns)	Can be soldered and welded or bonded with all-purpose glues. Materials are corrosion protected (e.g. galvanized) or later painted. Cut with tin snips or metal-cutting saw

| Nickel silver | Alloy of copper, nickel and zinc, silver colour and surface, good air-corrosion resistance | Nickel silver sheets are suitable for representing metallic and shining building elements. | Can be soldered; bonds well. Ideal for chipless processing (swaging) |
| Stainless steel (V2A) | Silvery grey, smooth, fine surface, non-magnetic. The material can be processed to stop it rusting. | Suitable for use in areas exposed to moisture (e.g. exteriors) | Bonded with glues (all-purpose glues) |

structured sheets such as channelled plates, corrugated sheeting and chequered plates; and sheets with round-hole, square-hole or elongated perforations, as well as expanded meshes.

To represent steel profiles realistically, it is also possible to buy miniature solid round profiles, round tubes, T-, L-, H- and I-profiles, square and rectangular profiles.

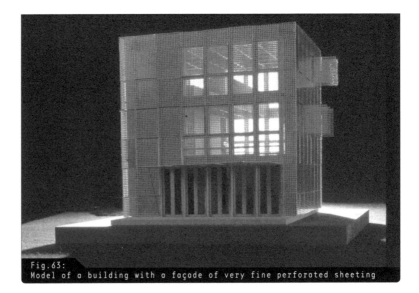

Fig.63:
Model of a building with a façade of very fine perforated sheeting

PLASTICS

There are so many different plastic products that it is difficult to describe them in general terms. Most plastics are malleable synthetic materials made of macromolecules. Carbon (an organic material) is one of the main constituents. All plastics can be processed easily and with a high degree of precision. Their light weight and stability combine to make them very useful in areas where other materials would be out of the question.

Polystyrene
models

The most common plastic used in modelling is polystyrene (PS). Being mass-produced, polystyrene – like polypropylene (PP) and polyvinylchloride (PVC) – is inexpensive and has a wide variety of applications. Many architects and modellers work with nothing but polystyrene. As a result, a special type of design and presentation has been developed for constructing architectural models. Polystyrene is white and smooth. It is ideal for doing precision work and making filigree forms. Models made solely of polystyrene offer the desired degree of abstraction and also provide plain and simple examples of three-dimensional architecture.

Nearly perfect results can be obtained using plastics, a feature that sets them apart from other materials. It is possible to work precisely to within fractions of a millimetre, which is a great advantage when making urban planning models, for example. Furthermore, it is possible to

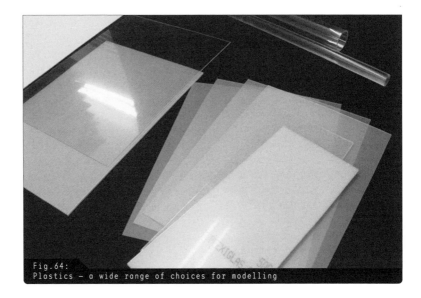

Fig.64:
Plastics – a wide range of choices for modelling

simulate transparent elements such as glass by using thin, transparent PVC foils. Plastics are an indispensable modelling material. Polystyrene is the material most widely used by architects in competition projects and in modelling in general.

After polystyrene, acrylic glass (chemical name: polymethyl methacrylate, PMMA; also known as perspex and plexiglass) is the plastic most widely used in architectural modelling. Being a thermoplastic material, it displays excellent thermal ductility. Furthermore, many of the varieties manufactured are ideal for representing glass panes, as well as glass and transparent building elements (e.g. in urban planning models). The surface can be modified. Satin matte structures can be made by grinding acrylic glass (so-called "wet grinding", with fine-grain sand paper, for example grain 600). Grid structures and patterns can be made in acrylic glass by milling, grooving or scoring it with a sharp utility knife blade.

There is a very wide range of plastics and plastic products. In modelling, too, far more types are used than are described here. The only criteria for using plastic are the form and colour desired and its surface properties. Among the plastic products available for modelling in the form of panels, foils and profiles, special mention should be made of polyester and polyethylene (PE plastics).

In addition to the above-mentioned "raw materials" for making architectural models, a number of other products – paints and varnishes, for instance – are also indispensable modelling materials.

\\ Hint:
In modelling, PS rigid foam is often finished in a different colour. Unfortunately, some paint solvents – especially if sprayed – react with the plastic compound and can even dissolve it. It is therefore advisable to carry out tests first.

\\ Tip:
Acrylic glass is often very expensive, and difficult to obtain from specialist dealers. It is therefore worth contacting processing companies or the manufacturer directly and asking for waste materials or samples.

Table 6:
Plastics — uses and properties

Plastic	Properties	Use	Processing
Polystyrene (PS): as a duroplastic, "hard" plastic	Shock-resistant, hard plastic. Matte, white, opaque panels are used in modelling. PS is not UV-resistant. Material thicknesses 0.3–5.0 mm	Universal: in all areas of modelling	Very easy to cut with a utility knife, the surfaces are easy to polish and very easy to mill. They can be easily bonded together using solvents or special PS adhesives and contact glues. Easy to paint or varnish
Polystyrene hard foam (e.g. Styrofoam)	A porous material manufactured in panels and blocks. Not shock-resistant. The surface can be easily depressed. Available in different colours, depending on the manufacturer.	For building and urban planning models	Very easy to cut with a hot wire cutter, and to cut or carve with a utility knife. It can also be polished and painted
Polypropylene (PP)	Heatproof, hard and tear-resistant plastic. In modelling, it is generally used in the form of thin, transparent or opaque foils. It has a non-scratchable surface, is UV stable, and available in various thicknesses	As a translucent foil, it is excellent for imitating matte glass surfaces and for designing lamps	Very easy to cut with a utility knife. It can be bent, folded, grooved, welted, moulded and punched. Before bonding, it must be pretreated, e.g. with Poly-Primer

Polyvinyl-chloride (PVC)	Depending on the mode of manufacture, either transparent or opaque, various material thicknesses	Transparent foils make good imitation glass in models, and can be used as thin foil in many different areas	Very easy to cut with a utility knife. It can be drilled, milled or turned. PVC surfaces can be bonded together with standard plastic glues and contact glues
Polycarbonate (PC)	Very strong, impact-resistant plastic, weather resistant, fine surface, transparent or milky-translucent plastic foils	Transparent foils make good imitation glass in models, and can be used as thin foil in many different contexts. It generally has a finer and smoother surface than PVC	Very easy to cut with a utility knife. Thick sheets can be scratched and broken. PC surfaces can be bonded together with solvents and contact glue and leave no residues
Acrylic glass (PMMA)	Very transparent and bright, excellent optical properties, similar to glass. Weather-resistant plastic, available in transparent, translucent or opaque form	As a transparent material for representing glass or water	Thin foils can be easily cut with a utility knife, thicker materials must be broken or sawn; moisten before grinding and polishing. Can be easily bonded with solvents, contact glues or special glues for acrylic glass

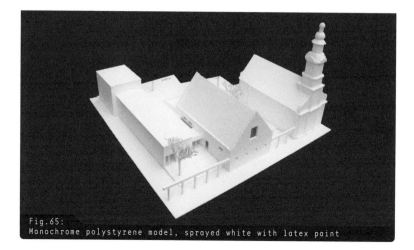

Fig.65:
Monochrome polystyrene model, sprayed white with latex paint

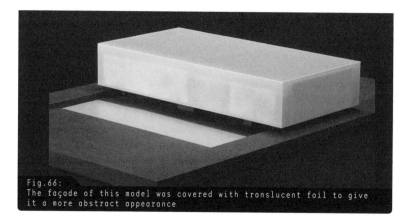

Fig.66:
The façade of this model was covered with translucent foil to give
it a more abstract appearance

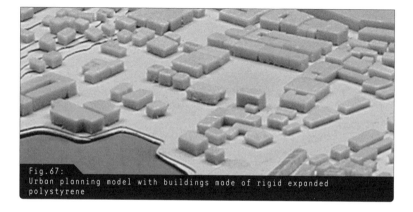

Fig.67:
Urban planning model with buildings made of rigid expanded
polystyrene

PAINTS AND VARNISHES

The surface of a material is not always the surface that will be visible on the finished model. Coats, films and paint finishes may be applied to many different grounds in order to modify the original design. These products also improve the resistance of the surface (insolation, UV light resistance, water-resistant surfaces, preventing yellowing).

Table 7:
Paints and varnishes – areas of application

Paints and varnishes	Use	Result
Paint sprays (colouring pigments with adhesives and propellents)	Can be used with most materials. However, care must be taken that chemical reactions do not take place between the solvent and the material (e.g. compatibility with polystyrene foam boards)	Different types of sprays can be used (silk matte or gloss) to match the colours of the surfaces
Clear varnishes	Can be used with many different materials. Applying clear, transparent layers, you can create nuances without the need for additional materials	For example, nuances in sites, topography and the building, varying intensities of colour or degrees of brightness on the surface of the material. Varnishes conserve the surface (e.g. of Finnboard, preventing the material from yellowing)
Acrylic paint	For painting specific building elements or surfaces on the model. It is easy to mix and the brush can be cleaned with water	The different materials can be made to match by applying a uniform monochrome coat; very intense, bright colours (depending on the pigmentation)

Wood stain	Stains can be used to change the natural colours of the wood surface. The original properties, such as the grain, are preserved	By changing the hue, different shades and nuances can be created. Coloured stains make the material look very different.
Oils and waxes	The surfaces of both wood and cardboard can be treated with these products, thus changing colouring and brightness	These protective surface coats can often be applied to intensify the impact of the surface properties of woods

PLASTER, CLAY AND MODELLING CLAYS

Materials such as plaster (gypsum) and clay, like the other materials presented here, form a distinct category of materials. People often limit themselves to using only the material from which the entire model is made. These materials are particularly suitable for presentations that focus not on the exact formal details but on a building's corporeality and massivity. Plaster, it might be added, can be cast in very precise, smooth forms.

Plaster

Gypsum is used as a building material on a scale of 1:1 (in the form of plaster and stucco, for example). Its chemical name is calcium sulphate, a compound that occurs naturally and as by-product of power stations.

In modelling, it is used as a pouring compound. First, a mould must be made. This is a time-consuming process, but its advantage is that you can cast a product as often as you wish.

\\Tip:
When you use paints, varnishes or other surface coats, it is worth doing tests first to see what effect they have. Using samples and testing materials, you will acquire a feel for the products' properties and for different ways of using them. Experimenting can be good fun too. Colours and contrasts are best judged under natural lighting.

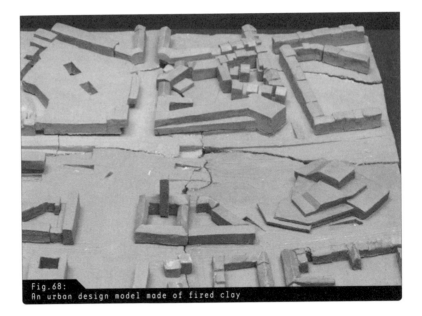

Fig.68:
An urban design model made of fired clay

Gypsum, as "modelling plaster", is available as a white powder. It is mixed with water and used either in liquid form or applied in a thicker consistency with a putty knife.

Liquid plaster quickly sets and hardens. Once it is in this state, it can be sandpapered and painted or varnished.

Clay

Clay has long been used to manufacture a wide variety of objects in different fields.

The history of architectural models shows that clay (also known as loam) has been used in certain areas since models were first built:

_ For the construction of forms: free forms, organically formed objects
_ Sculptures
_ Three-dimensional solid models, e.g. for urban development projects

The great advantage of clay lies in the fact that it is simple to use. Working with clay is also a tactile experience. With clay you can create "corporeal" three-dimensional, sketches, work on entire development processes

and make changes quickly and effortlessly. While you are processing clay, make sure that you always keep it sufficiently moist (with water) to prevent it from drying out and cracking.

When a clay model is ready, it has to be fired in kiln to preserve its form. The product is known as pottery or ceramics. It is used the building industry for making bricks and clay roof tiles.

Plastic modelling clay

In addition to the classic materials plaster and clay, other products are also available:

- Air-drying modelling clay: its processing properties are similar to those of clay, with the difference that it hardens in the air and can be subsequently processed with sanding tools – like wood.
- Plastic modelling clay/ plasticine: a modelling material that basically remains processible and formable, whilst preserving a constant degree of hardness. A typical feature of this material is that it becomes "softer" at higher temperatures, but retains a relatively firm consistency at normal room temperature. Plasticine has a familiar greyish-green colour. Plastic modelling clay is available in many different colours.

Assembly units are increasingly often used in modelling.

ACCESSORIES: TREES, FIGURES AND CARS

When clients first set foot in a new building, they often exclaim: "I imagined it would be much smaller (or bigger)." This is hardly surprising, since the only impressions they have of a project's scale before it is built are gained from drawings and models. And this is the crux of the matter: how can architects convey an accurate impression of the size and scale of the final structure? To give the viewer an idea of the real size, they can use "known quantities". Such reference points give the viewer a basis upon which he or she can imagine the finished product. Among the objects that convey an idea of scale are small-scale human figures. We all have an idea of our own height and can relate this to the model. If we read and grasp objects in relation to this "human scale", we find them easier to judge.

Accessories

In addition to figures, there are many other objects that help us visualize the scale of a project. Vehicles, available from specialist dealers, or represented by other objects, are indispensable in a multi-storey car park. The same applies to trees and plants, which must be shown if they are an

65

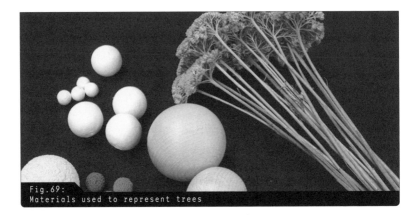
Fig.69:
Materials used to represent trees

important feature of the concept (in landscape planning or urban design projects). Balls, rods and simple, three-dimensional blocks can be used to represent trees. However, the best method is simply to use trees themselves. Various dried plants (such as yarrow), which are normally used in flower arrangements, make ideal miniature trees. If trees play an important role in the model design (site design, relationship of buildings to trees and the interior courtyard etc.), the abstract trees must be selected very carefully, since they are often decisive for the overall impression.

In architectural models, the accessories mentioned above are normally all you need. In some cases, however, other objects may be more suitable for illustrating the purpose of the future building:

_ Streetlamps as a line-forming element
_ Street furniture (benches, advertising pillars, signs)
_ Furnishings in interiors such as shops and restaurants
_ Trains, ships and aeroplanes, in the case of transport buildings

ρ

\\ Example:
Modelling figures are available in all scales
as injection-moulded products. For the common
scale of 1:200, grains of rice can be stuck
vertically into the base as an abstract
representation of people.

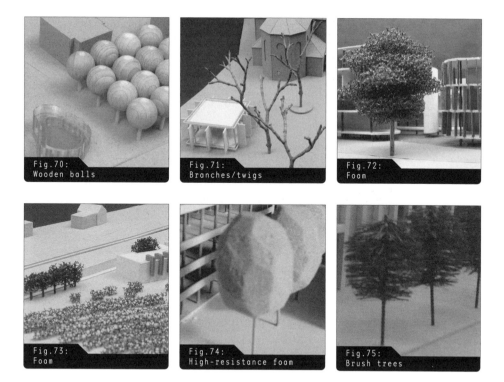

Fig.70:
Wooden balls

Fig.71:
Branches/twigs

Fig.72:
Foam

Fig.73:
Foam

Fig.74:
High-resistance foam

Fig.75:
Brush trees

Summary: Most of the materials mentioned above are obviously not specifically manufactured for making models. It is up to you, as the modeller, to use your imagination and apply unusual materials to the context of architectural models.

\\ Hint:

When you choose suitable materials, consider how long you want to use or keep the model. Many materials age – in this respect models are very similar to constructed buildings – changing the appearance of models as time goes by. Sunlight (UV radiation), in particular, darkens cardboard and wood. Finnboard, for instance, turns yellow very quickly. Although ageing affects the aesthetic appearance of wooden models, it has a far more detrimental impact on the durability of cardboard models.

Below, we shall examine different methods of making models and show you different ways in which you can make one yourself. These tips are intended as a guide to help you in your creative work.

A FEW PRELIMINARY THOUGHTS

Objectives of the presentation

Before you pick up your utility knife and cutting ruler, you should consider your objectives. Although modelmaking can be a very creative way of designing a building and a very pleasurable activity (e.g. tearing and joining pieces of paper), if you want to make a model for representational purposes, you should avoid proceeding by trial and error from the very start. Hence, you should begin by clarifying your goals.

You should first decide what you want to present. If it is a design principle (e.g. a stone slab with a glass hall), then this will influence your choice of scale, materials and the level of abstraction. If you want to present a concept to, for example, a professorial committee or representatives of building clients, you must decide exactly what you want to communicate to the target group. You should also consider whether they are likely to be very imaginative. In general, people teaching architecture have far more experience in judging designs, and are more likely to be familiar with abstract models than, say, building clients who have had little experience in the field of construction.

Relationship between plans and model

Furthermore, the presentation plans will influence the choice of material and the format of the mounting board, especially if it and the model are meant to form a coherent whole. Hence, you should carefully select the essential elements and graphically explore different levels of abstraction – using sketches, too, if necessary.

Deciding plan detail

The degree of detail shown in your model will depend on spatial relationships and the physical size of the mounting board you intend to use. If some parts of the design (e.g. a striking axis in the immediate surroundings) are very important, but too big to fit on a suitable base, you might have to reconsider the scale of your model.

THE MOUNTING BOARD

If the surroundings and the terrain are to play a decisive role in your concept, you should start by thinking about the mounting board. Although

this may not be appropriate for every project, it is always a good place to start. Begin by making a working model of the location. This can, of course, be used for the presentation too. Often, when people start working on a design, they are short of ideas, so it is often worth reproducing the terrain and topography and making a spatial analysis of the site. Very often, the best ideas arise when you get down to work. Another reason for reproducing the terrain at the beginning is that the workload generally tends to grow toward the end of a project. It is therefore worth preparing and finishing this part of the work before you do anything else.

When making the terrain (the "foundation") make sure that the dimensions of the whole model are right: if the model is too large it will be heavy and difficult to transport; if it is too small, it will not communicate enough information during the presentation. Boards manufactured from wood-based materials usually make good foundations. › see chapter Materials

If you already have a suitably sized mounting board for presenting the section you have chosen, you will now need a site plan to transfer the surroundings or the terrain to the mounting board. Once you have done this, you will have to transfer your geometric planning data onto the modelling material. You can use one of the following methods:

_ Frottage: copy the drawing as a mirror image, affix it to the material with adhesive tape and then rub it onto the material with the aid of acetone solvent. In the process, the printing ink is transferred from the drawing to the material.
_ Tracing with needles: mount the drawing on the material, pierce the key features into the material with a needle or a pounce wheel (a special modelling tool) and then trace the line geometry.
_ Drawing: the best way of making simple outlines is to draw a line on the material with a fine pencil.

\\Tip:
Transferring the typography of the terrain to the model is generally very time-consuming. If you are making a raised-relief model, select a material thickness that, in the desired scale, corresponds to the elevation lines on the terrain plan. This approach renders further changes unnecessary. First, make the required number of layers to fit the dimensions of the mounting board and glue an entire layer on to the mounting board. Now cut the first elevation layer out of the site-plan base, which has also been cut to size, and transfer it to the next layer of paperboard. Once you have glued the first layer, cut additional layers and transfer them one at a time to the others until you have created a perfect reproduction of the terrain. Note that you may have to create a new model of the terrain of the new construction site, which will then have to be integrated into the raised-relief model.

MAKING INDIVIDUAL BUILDING ELEMENTS

Modelling is more like constructing a prefabricated building than erecting a complete structure (from the primary construction to the finished product). Generally, it is advisable to finish building elements completely before you join them to others. Typical elements include:

_ Floor plate, ceilings, roof top and all of the structure's horizontal building elements
_ Walls, shear walls and façades, including the arranged window and door apertures as well as all vertical elements
_ Interior walls

Working from plans and sketches

These elements are made on the basis of architectural drawings (in the same way that a building is constructed on the basis of a building plan or work drawing). All we have on paper are the classic two-dimensional projections, e.g. the plan, the section and the elevation. However, the plans and the sections are equally important. They each provide two-dimensional views of a building. Together, however, they create a three-dimensional impression. The best method is to transfer the geometry of the plan to scale onto the material. There are different ways of doing this:

_ The walls and supports are mounted as indicated on the plan (three dimensions). This is a quick and easy method, regardless of whether you are using working models or urban design models.
_ All the important information in the plan is transferred to the desired material. › see above

Once the information in the plan has been evaluated and applied layer by layer, the height indications in the longitudinal sections and cross sections gradually assume concrete form.

\\Tip:
When you transfer the lengths and heights of the elements to the model, pay attention to the thicknesses of the materials. If you want to mitre a wall corner, both sides must be made to their full length. If the elements are to be butt jointed, however, you must deduct the width of the material of the projecting element.

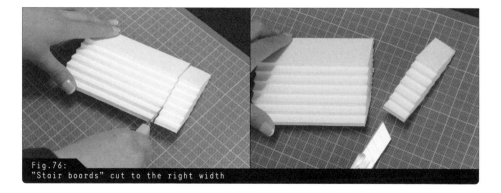

Walls are usually the most important parts of a building. When you are constructing models, you should design them not as single elements, but as part of a whole, and make them accordingly. In this respect, modelmakers can work far more efficiently than builders, since they can cut or saw walls into endless strips and then cut them to the required length when needed.

This method of "endless manufacturing" greatly simplifies the modelmaking process for both urban construction projects (involving rows of houses or buildings with the same cross section as "endless rows"), and for other building elements with the same cross sections (supports, window frames, floors etc.). It is worth making a large number of individual elements and then varying them, especially if you are experimenting with your model.

Stairs

Stairs are often a decisive element in any project and their representation is very important. In working models, stairs are simplified and installed in the form of slanted surfaces (ramps). This work can be done quickly, and everyone knows what the ensuing slopes are supposed to

\\ Example:
When you are making stairs, consider how many staircases you are going to have in your model. You can save yourself a lot of work by making the flights (in the case of single flight stairs) much wider and cutting off single sections in the desired width with a utility knife or a saw.

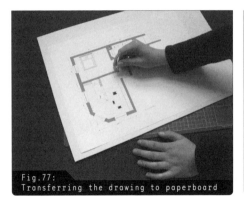

Fig.77:
Transferring the drawing to paperboard

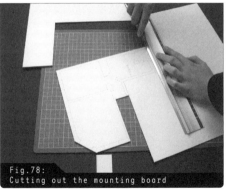

Fig.78:
Cutting out the mounting board

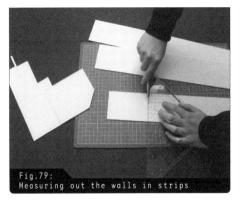

Fig.79:
Measuring out the walls in strips

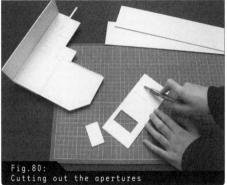

Fig.80:
Cutting out the apertures

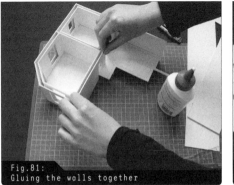

Fig.81:
Gluing the walls together

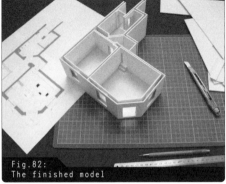

Fig.82:
The finished model

represent. Representing a real staircase with treads and risers is more time-consuming, but it also creates a more impressive result.

ASSEMBLING THE ELEMENTS

The elements should also be assembled systematically since in most cases you cannot take them apart without causing damage once they have been glued. An effective method is first to mount two exterior walls of a building and then successively glue the interior walls and the ceilings. Finally, you can complete the building by attaching the missing exterior walls.

A detailed simulation of windows and façade elements is also important for the expressive power of a building model. You should install the windows before assembling the exterior walls and façade. The same holds true for ceilings with openings for stairs and for walls and roofs with their apertures.

At times it may make sense to prefabricate all the elements associated with a specific phase of construction – i.e. entire building sections – and to assemble the entire unit afterwards. However, you should first make sure that, should the need arise, you can adjust the connected elements in case the building sections do not fit together with geometric precision.

FINAL TASKS AND ACCESSORIES

After all the elements have been assembled to form the building, a few final tasks remain before the model is complete. The process must be carefully planned, especially if you want to paint individual elements or

\\ Tip:
You should avoid using a utility knife on a model that has already been glued together since you can never work as precisely as you can on a cutting board. A better approach is to prefabricate as many elements as possible and then glue them together. You can check for measurement errors by temporarily joining the parts together. You can ensure that your model is stable by setting up the pieces at right angles.

the entire model. If, for example, a piece running through the entire building is to be a certain colour, you should make this piece and glue it together as a single unit so that you can paint it independently of the rest of the model, using a spray gun if necessary. If parts of the model are a certain colour, you should also consider whether it is best to add accessories such as trees and figures before or after painting.

Adding
accessories

It is definitely worth considering whether, and how, to use accessories as the model nears completion. Trees are a very popular element and can substantially improve an architectural model. Even so, trees and other accessories should only be included if they are relevant to your concept, but not if they merely serve as ornamentation. Often, modellers make the mistake of "planting" too many trees on the mounting board, which can divert attention from the actual subject of the model. As a general rule, if trees are architectural elements – that is, if they have a space-forming function – they should be part of the presentation, but they are not absolutely necessary (less is often more).

PRESENTATION

The finished model will usually be part of an exhibition or presented in conjunction with a talk. You should not leave this last step

\\ Tip:
If the accessories play too prominent a role, they may detract from essential features of the model: viewers will literally not see the architecture for the trees. To minimize this effect, you can paint the chosen materials to match the other materials used. Not only will the elements blend in better with the surroundings, but they will still be perceived in a spatial context. If you execute large public buildings such as concert halls, museums and the like as small-scale models, you can add small abstract figures to indicate paths, emphasize public spaces and give viewers a better understanding of the real context. If you want to create the impression that the structure exerts a magnetic pull, you might consider adding more concentrated groups of figures near the main entrance than those scattered across the grounds.

to chance. When pictures are hung on the wall, they are positioned at eye level to achieve the best possible effect. Models should also be presented in such a way that audiences can view them from the right angle. Whereas urban design models are usually viewed from above, you should ensure that people viewing an interior model can look into the spaces without assuming contorted or uncomfortable positions.

Constructing a base

To ensure that the model is exhibited at the right height, you can build a base (e.g. in the form of a pedestal) that conforms to model's shape. A base can be used to support a model conceptually: for instance, if a tall, narrow building is displayed, a tall, narrow base can illustrate the architectural concept from a distance.

The base of a group model is often equipped with wheels so that it can be moved easily from presentation to presentation. All you need to do at the new venue is replace the inserts.

Display cases

High-quality models can be presented in a display case to protect their surfaces and emphasize the object-like character of the architectural representation. A perspex case protects the model from damage at exhibitions and is particularly useful at public shows.

Hanging models on the wall

Urban design models (raised-relief models of landscapes) can be hung on the wall like a drawing or a plan (a kind of three-dimensional plan). Here, it is important to find out in advance what kind of wall is available. If plans are hung on partition screens, they may not be inordinately heavy.

> ✎

✎

\\ Tip:
You will probably be reluctant to throw your models away, but in the course of your studies, you will make so many that you will probably not have the necessary space to store them all. Since models stored in basement or attic spaces can be damaged by moisture and fluctuating temperatures, you might consider hanging your models on the wall after presentation. In this way, you can both store them and use them as wall decoration.

IN CONCLUSION

The study of architecture confronts students with a plethora of demands and challenges. Among other things, they must learn to make good models. Many of these models are created for presentational purposes just before an assignment is due. The potential they offer as design and work tools is overlooked. Studying architecture involves learning about technical matters as well as artistic and creative processes. Models are a way to explore space and proportions and to promote three-dimensional thinking. Models show the ramifications of paper sketches and also help students train their ability to imagine the spatial relations of two-dimensional drawings.

Models are also a method of communicating with a lay audience. If a client hires an architect to design a building, it is ultimately the model and not the detailed plans that will give him or her a concrete idea of the architect's "product". The model provides a foundation for approving and rejecting ideas, making improvements and fleshing out details. The different roles that the level of detail plays for architects and clients are reflected in the ways they respond to the model: clients see the model as a finished result and want a high level of detail because they are eager to see the project completed. Architects, on the other hand, prefer a model that is only moderately accurate since it will allow them greater creative freedom.

For both, models round off the ways a project can be represented. As the three-dimensional implementation of a design idea, a model is every bit as important as presentation drawings.

APPENDIX

ACKNOWLEDGEMENTS
Special thanks go to:

_ Chair of Building Theory and Design, Professor Arno Lederer/
Professor Daniele Marques, University of Karlsruhe
(Photographs of models that were built over the last few years for
design and end-of-term projects in design theory. Master model-
maker Manfred Neubig provided modeling courses to support the
design process.)
_ Gerstäcker-Bauwerk GmbH, modelmaking materials and art sup-
plies, Thomas Rüde and Marc Schlegel, Karlsruhe
(provided advice on materials and assistance when tools and mod-
elmaking materials were photographed)
_ Wood workshop at the Department of Architecture, workshop su-
pervisor Wolfgang Steinhilper, University of Karlsruhe
(assistance with photographs)
_ Metals workshop at the Department of Architecture, workshop su-
pervisor Andreas Heil, University of Karlsruhe
(assistance with photographs)
_ Christoph Baumann, Karlsruhe (model photographs)
_ Verena Horn, Karlsruhe (assistance with photographs)
_ Peter Krebs, Büro für Architektur, Karlsruhe (model photographs)
_ Stefanie Schmitt, Stutensee (model photographs)

PICTURE CREDITS

The following photographs were generously provided by the Chair
of Building Theory and Design, Professor Arno Lederer/Professor Daniele
Marques, at the University of Karlsruhe. Professor Lederer supervised the
designs. The research associates were Kristin Barbey, Roland Kötz, Peter
Krebs and Birgit Mehlhorn. Manfred Neubig oversaw the modelmaking
that accompanied the design process. If not otherwise indicated, photo-
graphs were taken by Thilo Mechau, on staff at the photography workshop
of the Department of Architecture.

Fig. 1 Student project, design, Reykjavik harbour, Florian
 Bäumler
Fig. 5 Student project, design, Palace of the Republic, Ruwen
 Rimpern
 Model of the urban surroundings: Manfred Neubig
Fig. 6 Student project, design, Reykjavik harbour, collaborative
 urban design model

Fig. 21 1st row: student project, design, "Do it again,"
 Steffen Wurzbacher
 3rd row: student project, design, "Do it again,"
 Matthias Rehberg
 4th row: student project, design, "Do it again,"
 Ioana Thalassinon
Fig. 24 End-of-term project for building theory course, collabora-
 tive model made of plasticine, photo: Cornelius Boy
Fig. 26 Left: student project, design, Palace of the Republic,
 Marc Nuding
 Right: student project, design, Islamic community centre,
 Axel Baudendistel
Fig. 27 Master's project, seaside resort in Barcelona, Philip Loeper
Fig. 48 Student project, design, Reykjavik harbour, Holger
 Rittgerott
Fig. 49 Student project, design, "Do it again," Lisa Yamaguchi
Fig. 50 Student project, design, "Do it again," Andrea Jörder
Fig. 51 Student project, design, "Do it again," Lisa Yamaguchi
Fig. 60 Student project, design, "Do it again," Benjamin Fuhrmann
Fig. 61 Student project, design, Reykjavik harbour, Markus
 Schwarzbach
Fig. 62 Student project, design, Reykjavik harbour, Kuno Becker,
 Tina Puffert, Holger Rittgerott
Fig. 66 Student project, design, Palace of the Republic, Matthias
 Moll

Fig. 67 Student project, design, Reykjavik harbour, collaborative
 model
Fig. 68 Student project, design, Islamic community centre, Axel
 Baudendistel

The following photographs were made available by Büro für Architektur Peter Krebs in Karlsruhe.

Fig. 4 Competition model, Mainhardt community centre
Figs 12, 13, 43 Competition model, Church of St Augustine,
 Heilbronn
Fig. 14 Competition model, Stella Maris Chapel, Stuttgart
Fig. 25 Competition model, St George's parish hall, Riedlingen
Fig. 65 Competition model, community centre, Schwetzingen

The following photographs were made available by Christoph Baumann, Karlsruhe:

Figs 70, 71, 72, 73, 75 Details from study models

The following photographs were made available by Bert Bielefeld, Dortmund:

Figs 11, 16, 45–57, 74

The following photographs were made available by Isabella Skiba, Dortmund:

Figs 8–10, 44

The following photographs were made available by Stefanie Schmitt, Stutensee:

Fig. 18 Study model, St Francis Kindergarten
Fig. 19 2nd row: Master's project, Olympia station, Stuttgart
Fig. 63 Master's project, Olympia station, Stuttgart

The author has supplied Figs 2, 15, 17, 20–23, 28–42, 52–59, 64, 69,
76–82

ALSO AVAILABLE FROM BIRKHÄUSER:

Basics Design and Housing
Jan Krebs
ISBN 3-7643-7647-3

Basics Materiality
Manfred Hegger, Hans Drexler, Martin Zeumer
ISBN 3-7643-7685-6

Basics Technical Drawing
Bert Bielefeld, Isabella Skiba
ISBN 3-7643-7644-9

Basics Masonry Construction
Nils Kummer
ISBN 3-7643-7645-7

Basics Roof Construction
Tanja Brotrück
ISBN 3-7643-7683-X

Series editor: Bert Bielefeld
Conception: Bert Bielefeld, Annette Gref

Layout and Cover design: Muriel Comby
Translation into English: Adam Blauhut, Robin Benson
English Copy editing: Monica Buckland

A CIP catalogue record for this book is available from the Library of Congress, Washington D.C., USA

Bibliographic information published by Die Deutsche Bibliothek
Die Deutsche Bibliothek lists this publication in the Deutsche Nationalbibliografie; detailed bibliographic data is available on the Internet at http://dnb.ddb.de.

This book is also available in a German (ISBN 3-7643-7648-1) and a French (ISBN 3-7643-7956-1) language edition.

© 2007 Birkhäuser –Publishers for Architecture, P.O. Box 133, CH-4010 Basel, Switzerland Member of Springer Science + Business Media

Printed on acid-free paper produced from chlorine-free pulp. TCF ∞
Printed in Germany

ISBN-10: 3-7643-7649-X
ISBN-13: 978-3-7643-7649-9

9 8 7 6 5 4 3 2 1 www.birkhauser.ch